Lights, Camera, Fashion!

By Sara W. Easterly

Welcome to the Studio!

To begin creating your masterpieces, turn to page 4.

If you have questions or comments about this product, please visit
www.smartlabtoys.com/customerservice.html and click on the Customer Service Request Form.

Edited by Nancy Waddell Cortelyou
Written by Sara W. Easterly
Art direction and packaging design by Eddee Helms and Megan Gangi
Illustrated by Jaime Temairik
Design assistance by Scot Burns
Product photography by Keith Megay
Additional photography by Grace B. Lee and Jennifer A. Ramirez, ICANDI Studios
Product development by Lauren Saint Cavanaugh
Production management by Jennifer Marx and Blake Mitchum
Project management by Beth Lenz and Wendy Carmical
Photo research by Zena Chew
Special thanks to Kiah Helms, Cecilee Fernandez, Heather Dalgleish,
Todd Bates, Breanna Guidotti, and Sara DeBell

Printed, manufactured, and assembled in China, June 2011, by Winner Printing & Packaging Ltd.

Lights, Camera, Fashion! is part of the SmartLab® Fashion Studio kit.
Not to be sold separately.

2 3 4 5 15 14 13 12 11
ISBN: 978-1-60380-127-0
SL10116-11649

> I don't
> design clothes,
> I design dreams.
> —Ralph Lauren,
> fashion designer

WORK IT

Congratulations on deciding to become a fashion designer! You already know you love clothes. Now it's time to tap into your artistic sense of personal style and turn your ideas into outfits!

You'll learn to draw all those clothes that are so fun to wear. Before long, you'll be putting together outfits with colors, patterns, and textures that nobody ever thought to mix together before. When you're finished, you'll have several complete collections—just like a true fashion designer!

Table of Contents

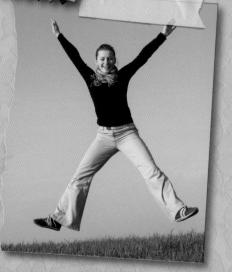

FASHION FACT!

Yves Saint Laurent is known for being the youngest fashion designer ever. He became Christian Dior's assistant at the age of 17!

Kit and Kaboodle

𝒜ll the tools you need to launch your career as a fashion designer are included in this kit.

MODEL ACETATE

The perfect fit model for all the clothing silhouette clings in this kit.

LIGHT TABLET

With batteries (not included), it lights up so you can trace the silhouette clings onto sketch paper.

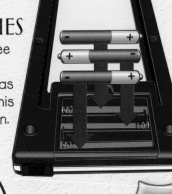

BATTERIES

Install three 1.5v AAA batteries, as shown in this illustration.

Your light tablet is powered by four LEDs.

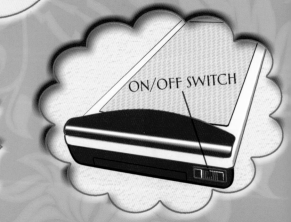

ON/OFF SWITCH

BATTERY CAUTIONS

- To ensure proper safety and operation, the battery replacement must always be done by an adult.
- Never let a child use this product unless the battery door is secure.
- Keep all batteries away from small children, and immediately dispose of any batteries safely.
- Batteries are small objects and could be ingested.
- Nonrechargeable batteries are not to be recharged.
- Rechargeable batteries are not recommended for use with this toy.
- The supply terminals are not to be short-circuited.
- Rechargeable batteries are to be removed from the toy before being charged.
- Rechargeable batteries are only to be charged under adult supervision.
- Different types of batteries or new and used batteries are not to be mixed.
- Only batteries of the same or equivalent types as recommended are to be used.
- Do not mix alkaline, standard (carbon-zinc), or rechargeable (nickel-cadmium) batteries.
- Batteries are to be inserted with the correct polarity.
- Exhausted batteries are to be removed from the toy.

COLORED PENCILS
Choose from 10 fashionable colors.

NOTE:
The pencils come in a container. Don't throw it away! It fits into the bottom of the light tablet for easy on-the-go storage!

SILHOUETTE CLINGS
The outlines of tops, pants, skirts, dresses, jackets, and accessories are all on traceable clings.

NOTE:
Some silhouette clings have dotted lines to show you where to trace if you want a variation. You can try shorter sleeves, shorts instead of pants, or a bikini instead of a maillot.

SKETCH PAPER
25 sheets to get you started.

NOTE:
Use 8½" x 11" paper, cut into thirds, in your light tablet.

IDEA BOOK

Once you get going, design ideas will start popping into your head all the time. Before you forget, collect them in an idea book. Make sketches or attach things that inspire you, like colorful ribbons, dried flowers, fabric scraps, or pictures from magazines, called tear sheets in the fashion world. Anything goes!

5

Let Loose with your Light Tablet

Your first job as a fashion designer is to learn how to use your two most important tools—the light tablet and silhouette clings. You should have already installed the batteries into your light tablet. If not, turn back to page 4 to find out how.

1. DESIGN YOUR OUTFIT

❀ Locate your model acetate and choose your clings. For our example, we used the boatneck top, A-line skirt, and pointy boots.

❀ Place the clings on the acetate. You can easily move the clings to line up exactly where you want them.

2. DO A FULL TURN

❀ When you are done adding the clings, flip the acetate so the clings are underneath. This way, when you trace, you won't have unwanted bumps in your drawing.

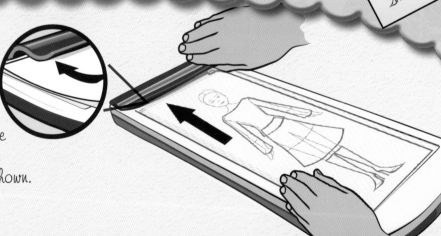

3. SHINE THE LIGHT

❀ Place a piece of sketch paper on top of the model acetate.

❀ Slide both the paper and the acetate under the clip at the top of the light tablet, as shown.

❀ Turn on the light tablet.

4. SKETCH YOUR STYLE

❀ Trace only the lines you want.

In this example, you want to draw the shirt first, then the skirt. Next come the boots, then the lines of the model's body—but only the ones that aren't covered up by her clothing.

❀ If you need to, you can remove clings as you go.

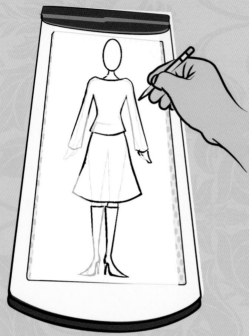

5. ACCESSORIZE

❀ When you are done tracing your outfit, remove both the drawing and the acetate.

❀ Turn off the light tablet.

❀ Place the clings back on their sheets.

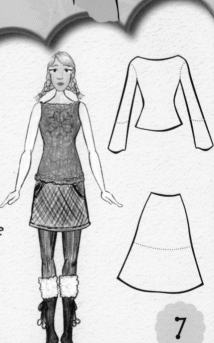

6. WORK IT

❀ Use your colored pencils to bring your design to life!

❀ Turn to page 11 for some high-end pencil techniques.

WHAT ABOUT THOSE DOTTED LINES?

You can use the same silhouette clings from this example to make a variation of this outfit. Using the dotted lines, you now have a sleeveless shirt and a miniskirt.

7

PARTS OF A COLLECTION

As you begin to design your outfits, you may be amazed at the number of choices! Did you ever realize how many kinds of pants there are? There are just as many different shorts, skirts, dresses, shirts, and jackets. What you'll discover is that most items are built from a few basic shapes. Pants can become shorts. A tank and a skirt can become a dress.

Tops

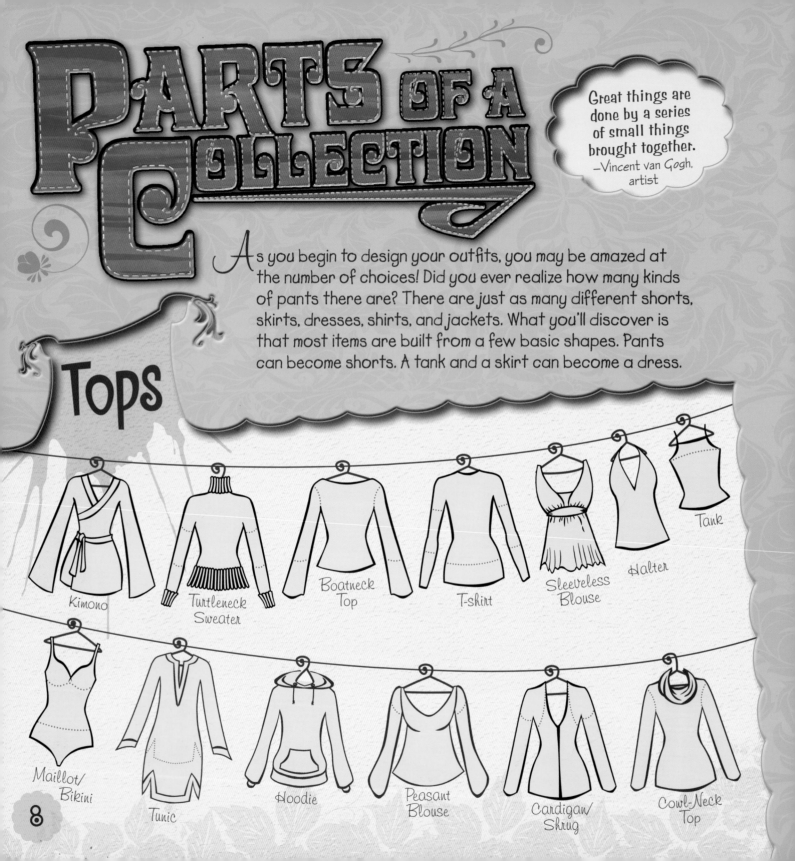

Kimono

Turtleneck Sweater

Boatneck Top

T-shirt

Sleeveless Blouse

Halter

Tank

Maillot/ Bikini

Tunic

Hoodie

Peasant Blouse

Cardigan/ Shrug

Cowl-Neck Top

Skirts

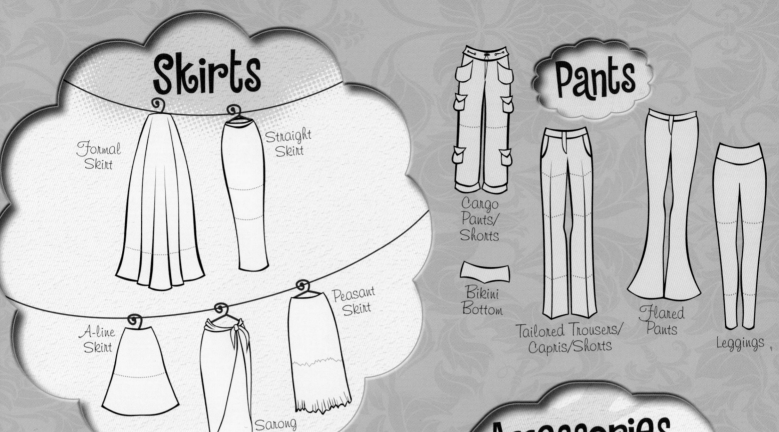

Formal Skirt

Straight Skirt

A-line Skirt

Sarong

Peasant Skirt

Pants

Cargo Pants/Shorts

Bikini Bottom

Tailored Trousers/Capris/Shorts

Flared Pants

Leggings

Jackets & Dresses

Loose Coat

Opera Coat

Shift Dress

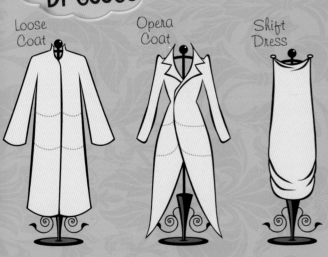

Accessories

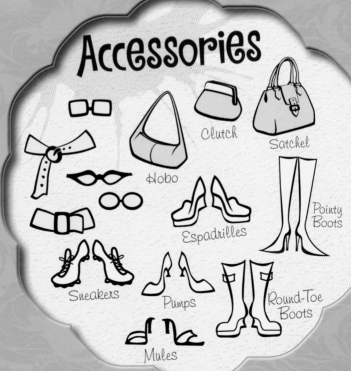

Clutch

Satchel

Hobo

Espadrilles

Pointy Boots

Sneakers

Pumps

Round-Toe Boots

Mules

Crazy about Color

In any art form, color is a powerful tool. It's no different in the world of fashion, where color choice can make or break an outfit, affect your mood, and symbolize status. Our color wheel below shows fashion experts (like you!) the relationships between six colors, including primary colors, secondary colors, and complementary colors.

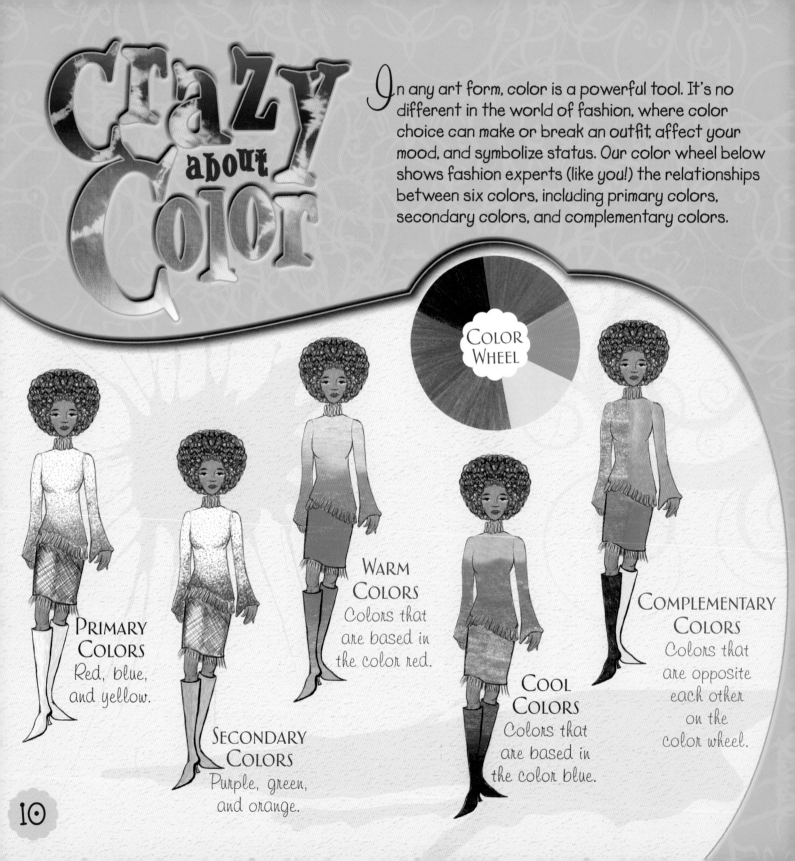

COLOR WHEEL

PRIMARY COLORS
Red, blue, and yellow.

SECONDARY COLORS
Purple, green, and orange.

WARM COLORS
Colors that are based in the color red.

COOL COLORS
Colors that are based in the color blue.

COMPLEMENTARY COLORS
Colors that are opposite each other on the color wheel.

Pencil Techniques

Use different types of pencil strokes to create these different effects. Your illustrations will look more realistic.

CIRCULAR
Overlapping curlicues—helpful for drawing soft or fuzzy clothes, as well as curly hair.

SHARP PENCIL
Good for small items, like earrings, and patterns with detail, like lace.

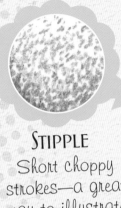

STIPPLE
Short choppy strokes—a great way to illustrate a leopard print or another funky pattern.

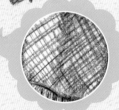

CROSSHATCH
Diagonal crisscross strokes—good for drawing denim and tweed.

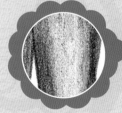

DULL PENCIL
Perfect for drawing jeans when you want a faded, washed-out look.

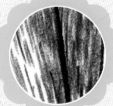

VERTICAL LINE
Long up-and-down strokes placed side by side can look like leather or fake fur.

NOTE:
Remember, you only have to hint at shapes, patterns, and textures. They don't have to be precise!

11

ALL THAT PIZZAZZ!

FABRICS: PATTERNS AND TEXTURES

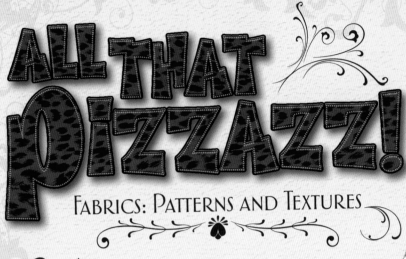

What would your clothes be without zing? *Bor-ing!* Fabrics with pattern and texture bring your clothes to life.

Animal Print
Printed fabric can look like zebra stripes, leopard spots, or cow splotches.

Polka Dots
Even though it makes no sense, polka dots were named after a dance popular in the late 1800s, called the polka.

Plaid
This classic pattern dates back to the 1500s. In Scotland, clothes made from plaid-patterned fabric, called tartan, symbolize which clan, or family, you're from.

Houndstooth Check
These pinwheel shapes got their name because the jagged checks look like the back teeth of a hound dog.

Stripes
In medieval times, striped clothes were forced upon jugglers, servants, and prisoners. Thanks to the popularity of the pattern in the US and French flags, today everybody is free to wear stripes!

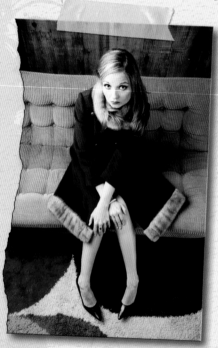

Fake fur trim can give a plain coat punch!

Everyday Fabric

CORDUROY
A heavy cotton fabric with a ribbed nap.

DENIM
A durable cotton twill.

TWEED
A rough, thick wool fabric.

Fancy Fabric

SATIN
A glossy, silky fabric.

CHIFFON
A lightweight gauzy fabric.

EMBELLISHMENT EXTRAVAGANZA

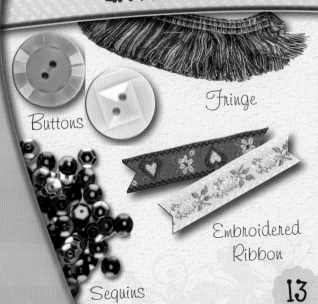

Buttons

Fringe

Embroidered Ribbon

Sequins

13

Everyday Runway

Collection

High fashion doesn't always mean high heels. Jeans, tanks, flip-flops, tees, capris, and hoodies—clothes you wear practically every day—are a necessary part of your collection. In fact, everyday outfits are the most important. You wear them more than any other. They need to be hip, hot, and happening!

FASHION FACT!

Clothes that you buy from the store that are not custom-made are from a designer's prêt-à-porter collection, which is French for ready-to-wear.

This watercolor illustration highlights the matching bag and shoes worn by a woman talking on her cell phone. Now that's "everyday"!

MALL

Trace here.

Trace here.

Polka dots are a simple way to add color and texture to any item of clothing.

Sketch in scallops to soften the edges of this peasant blouse.

Feathers top off this basket-weave bag.

A green apple inspired the color of these tailored capris.

Don't forget the cuffs.

CATWALK!
Fashion designers toil over their collections. Then, each spring and fall, they debut their work at fashion shows. People line the catwalk to see what designers have stitched up for the new season.

Everyday Runway
Collection

Add details like hoop earrings and a floral corsage.

CINEMA

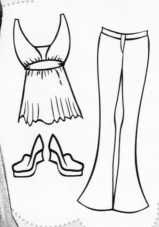

Sketch in a second ruffle below the top for a layered look

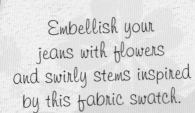

Most everyday outfits begin with jeans.

Embellish your jeans with flowers and swirly stems inspired by this fabric swatch.

Denim Texture!

Use a pencil with a dull point to create the denim texture for these jeans.
OR
Place a piece of sandpaper under your drawing.
Fill in with a blue colored pencil.

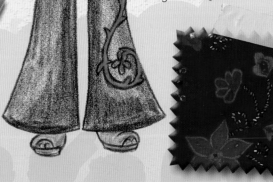

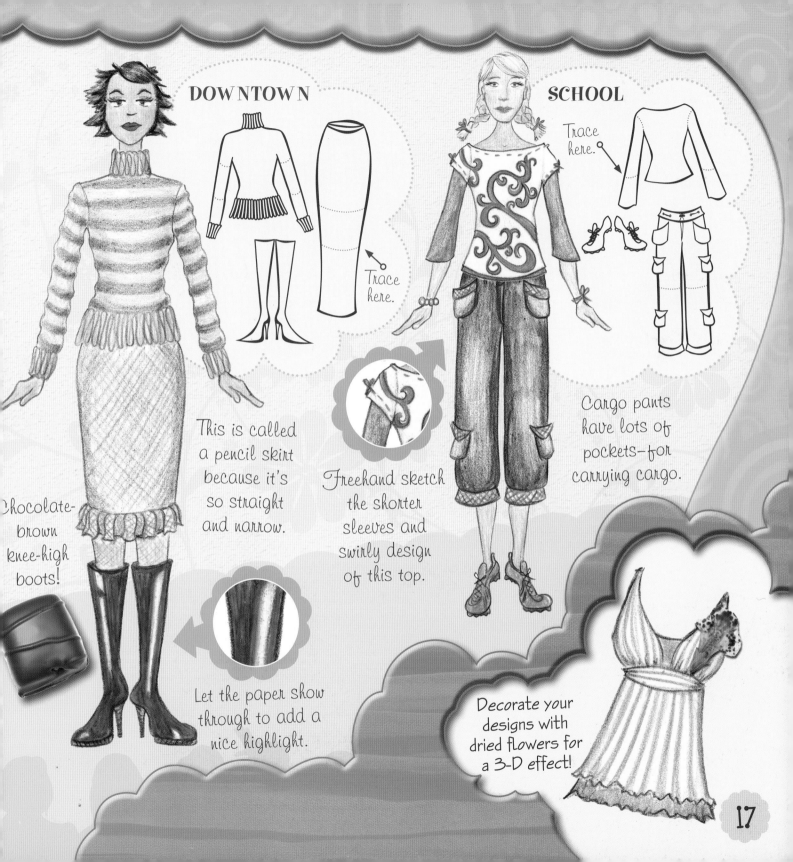

DOWNTOWN

SCHOOL

Trace here.

Trace here.

This is called a pencil skirt because it's so straight and narrow.

Chocolate-brown knee-high boots!

Freehand sketch the shorter sleeves and swirly design of this top.

Cargo pants have lots of pockets—for carrying cargo.

Let the paper show through to add a nice highlight.

Decorate your designs with dried flowers for a 3-D effect!

17

Couture
COLLECTION

Special occasions call for special clothes. Couture clothes are for dressing up—ball gowns, red-carpet dresses, or any ensembles that make you feel like a princess. A couture collection is your chance to design your most glamorous—and expensive—outfits.

ACCESSORIZE!
Diamonds are a girl's best friend. Couture clothes demand the best from your jewelry box. Don't forget to include earrings, necklaces, and bracelets to match your outfits!

Use pen and ink—plus a little fabric and glue—to make an illustration like this one.

RED CARPET

A feathered pen becomes a feather pin.

Trace here.

To create the top of this strapless dress, use the tank silhouette but trace the curved line, as shown.

A mix of lines, dots, and white space creates the shimmery look of this fabric.

Top to bottom, this dress looks as delicious as this slice of cake!

FASHION FACT!

In the real world of fashion, couture items often don't make it past the runway. They are expensive to make because of the fancy fabrics used and because they are hand-sewn—often by many artisans at once!

19

Couture COLLECTION

Full skirts always make a big statement.

Every princess needs a tiara.

BALL

Trace here.

Add a touch of drama with full-length white gloves

Sheer Pressure!

1. Press lightly with your pencil in places where light would shine on the skirt.

2. Press harder in the folds that are hidden from the light.

Scribble when you draw the fur on this zebra coat.

GALA

OPERA

Zigzags and a freehand-sketched crisscross skirt hem add motion to this evening dress.

Soft shading gives this jacket a velvety look.

A flowing, sheer skirt peeks out from underneath the fur coat.

Apply the pattern from this zebra to a jacket and shoes.

Use real sequins or glitter to create 3-D embellishments for your couture illustrations!

LAST RESORT Collection

Now it's time to create your activewear collection, sometimes referred to as a designer's resort collection. These are outfits you wear to the beach or a swimming pool. Or they're casual clothes for when you're hanging out with your friends.

Resort clothes should be both trendy and tough. Design sun hats to protect faces and eyes from the sun's bright rays. Add pockets to sporty skirts and shorts, so purses aren't a pain.

SHOCKING!

One hundred years ago a swimmer was arrested because of her bathing suit! Then, it was considered offensive for a woman to expose her arms, legs, and neck. Times have really changed!

Combine watercolor with a fabric swatch to design the perfect outfit for a day at the beach.

I'm not trying to do something different; I'm trying to do the same thing but in a different way.
—Vivienne Westwood, fashion designer

Rickrack

Poolside

Transform this beach umbrella into a hat for around-the-clock shade!

The print on these bikini bottoms calls to mind ripples in the sand.

Borrow flowers from this bathing cap to dress up a tankini.

FASHION FACT!

A sarong is one of the most universal items of clothing. It's worn throughout the world by girls and boys alike! Turn the page so see our picnic-inspired sarong.

23

LAST RESORT collection

Beachside

Hawaiian kukui nuts make a tasty food—but a juicier accessory.

Make Some Waves!

1. Sketch the horizontal lines.

2. Sketch the vertical lines, so you have loose square shapes.

3. Color in every other square.

4. Don't forget the fringe!

Ready to picnic, with a basket purse and a sarong that doubles as a blanket!

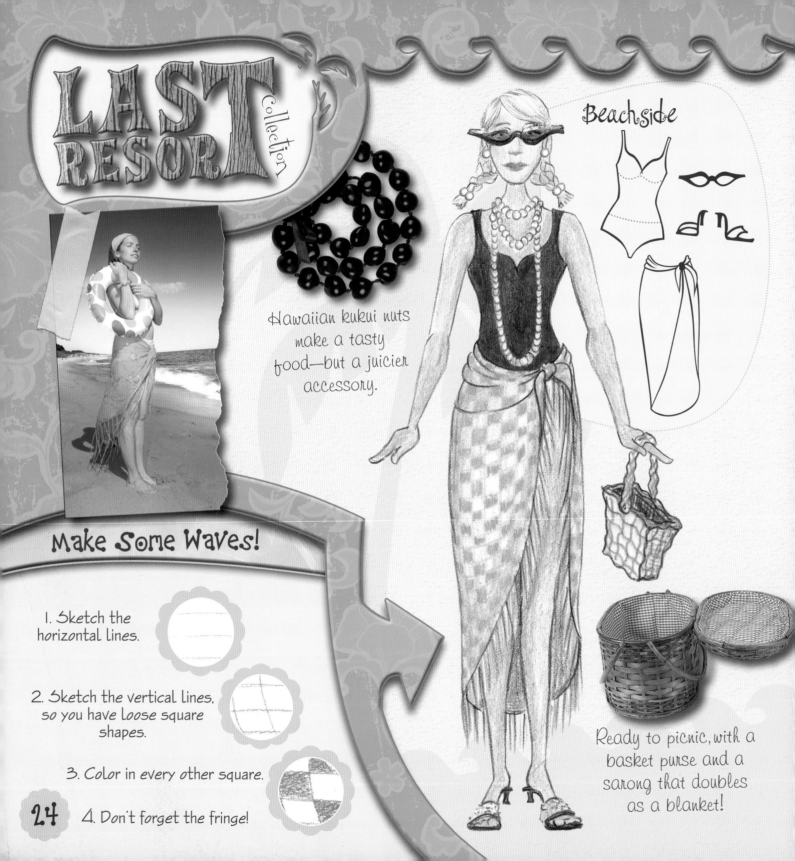

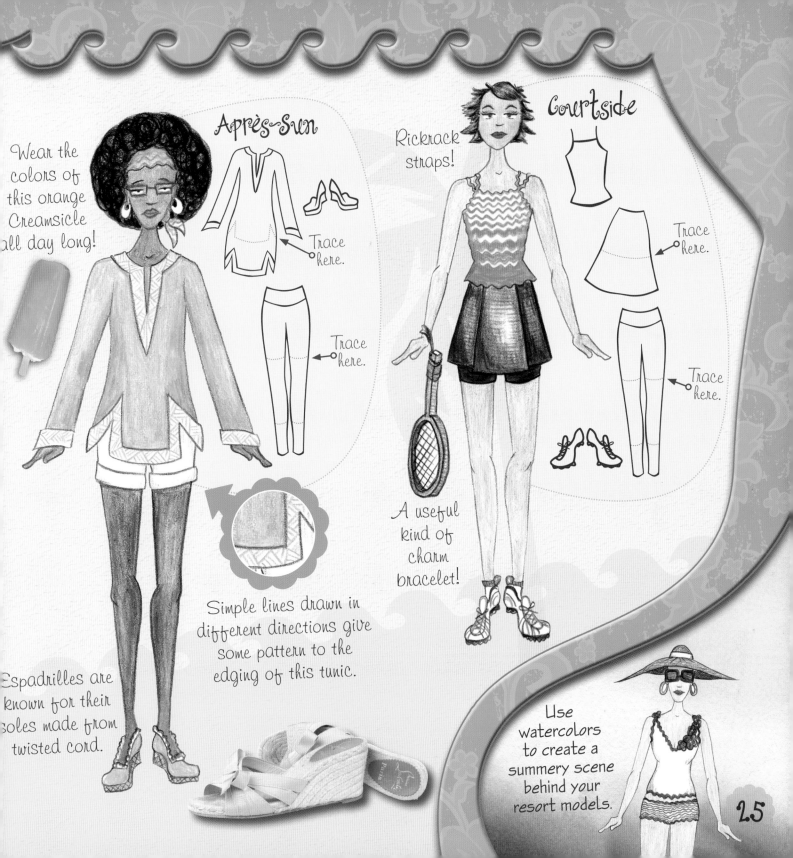

Wear the colors of this orange Creamsicle all day long!

Après-sun

Trace here.

Trace here.

Espadrilles are known for their soles made from twisted cord.

Simple lines drawn in different directions give some pattern to the edging of this tunic.

Rickrack straps!

Courtside

Trace here.

Trace here.

A useful kind of charm bracelet!

Use watercolors to create a summery scene behind your resort models.

25

MODERN VINTAGE
Collection

Throughout time, certain groups of people have been famous for the outfits they've worn. Women in Japan used to be known for wearing kimonos. Punk rockers in London started a distinctive look that made its way around the world. From geisha girls to punks and from flappers to princesses, historical clothes continue to inspire modern-day collections.

FASHION FACT!

Paris used to be the world leader in fashion. Today there are lots of other fashion capitals, including New York, London, Milan, and Tokyo. Every spring and fall, people flock to fashion shows in these cities.

The fabric of this matching dress and bag looks like a print made popular in the 1960s.

GEISHA

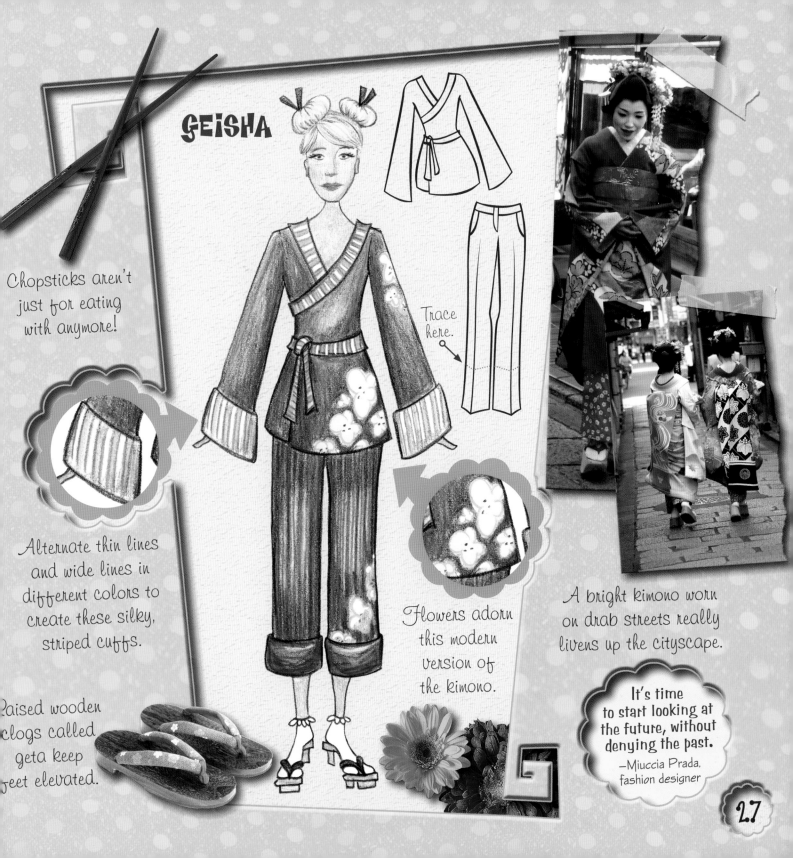

Chopsticks aren't just for eating with anymore!

Trace here.

Alternate thin lines and wide lines in different colors to create these silky, striped cuffs.

Raised wooden clogs called geta keep feet elevated.

Flowers adorn this modern version of the kimono.

A bright kimono worn on drab streets really livens up the cityscape.

It's time to start looking at the future, without denying the past.
—Miuccia Prada, fashion designer

MODERN VINTAGE Collection

PUNK

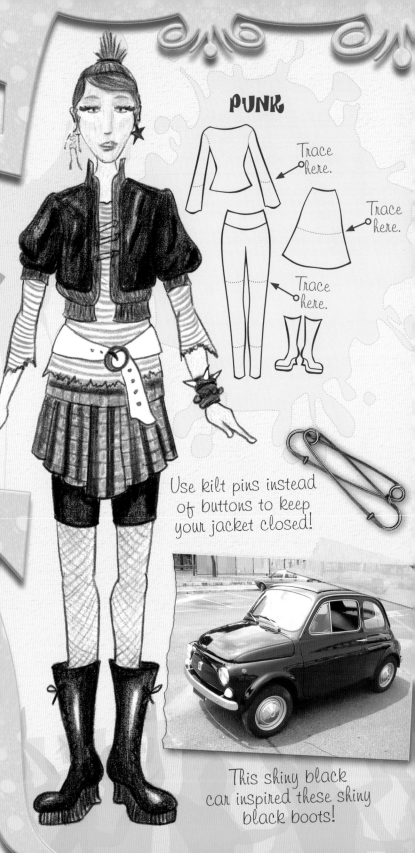

Trace here.

Trace here.

Trace here.

Freehand sketch this puffy-sleeved cropped jacket.

Use kilt pins instead of buttons to keep your jacket closed!

This shiny black car inspired these shiny black boots!

Map Out Your Pleats!

1. Make one big horizontal rectangle across the top third of the miniskirt.

2. Draw one big vertical rectangle down the center of the skirt.

3. Make narrower vertical rectangles on either side, until you reach the edge of your drawing.

4. Now round the bottom edges of each rectangle.

FLAPPER

The shoulder detail of this shift dress looks like fireworks. Now that makes it pop!

Fringe the bottom of this dress with short, quick straight lines.

PRINCESS

This modern princess wears her jeweled crown as a bracelet.

GET THIS!
Use these silhouettes to get the basic idea, but get creative by adding short puffy sleeves, a stand-up collar, a corset, and striped slippers.

See how this 1920s flapper inspired our modern-day outfit.

Use metallic ink pens to highlight accessories like belt buckles and jewelry.

Give that Brand a Hand

A brand is the name a company uses to represent its product, such as a line of clothes. The name can have a picture with it, or just be written in a special way. This becomes the company's logo. The brand name is usually on a label inside your clothing, but sometimes the logo is visible for all to see. This is so common that you might not always notice it.

Create Your Own Brand

Pretend you're running your own clothing company. Think of a catchy name, or use your own name. Design a special logo for your company.

Lucy's line

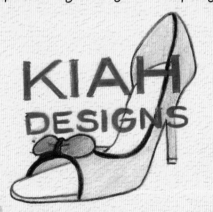

KIAH DESIGNS

Lucy

STYLISH!
Just like cuts and fabrics, brands go in and out of fashion. When you wear a brand name, everyone sees who made your outfit. You're announcing to the world, "Look at me. I'm in style!"

Fashion Portfolios

You've worked hard creating your collections. Now it's time to share them. A fashion portfolio is your tool for showing off your best work.

Paper Portfolio

1 Fold the piece of paper down the middle the long way.

Make a sharp crease, and then unfold the paper.

2 Fold in the short ends about 1 1/4" for a 9" x 12" (1" for an 8 1/2" x 11").

These folds will keep your drawings from slipping out of the portfolio.

fold 2

fold 2

fold 1

NOTE: Use a 9" x 12" piece of construction paper. (A regular 8 1/2" x 11" piece of paper works too).

3 Refold the long fold down the middle. Decorate however you wish.

Ribbon Closure

1 Punch four holes in your closed portfolio, as shown.

2 Cut two pieces of ribbon, 18" each, and wrap the ends with tape.

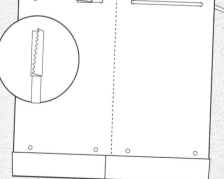

3 Open your portfolio and thread the ribbon through the holes, as shown.

Notebook Portfolio

1 First you need a notebook or blank artist's journal.

Then add a little creativity.

2 Use magazine cutouts, buttons, ribbons, beads, or sequins to decorate the front of the notebook.

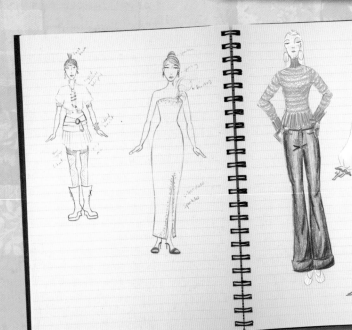

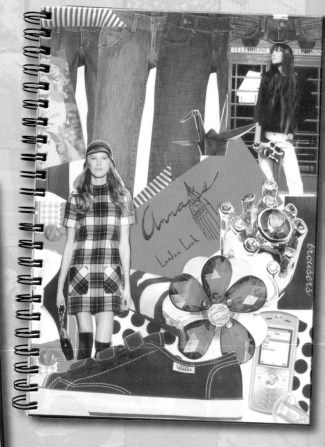

NOTE: Add notes and decorate the pages, if you want.

3 Mount your drawings to the inside pages using photo corners or rubber cement.

WELL DONE!

You're now on your way to becoming an expert in fashion design and illustration. Enjoy sharing your new talent with your family, friends, and teachers!